Dale —

May angels always
be there, and watch over
you and your wonderful
family.

fondly.
Pam

16. May. 1997

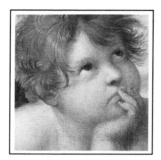

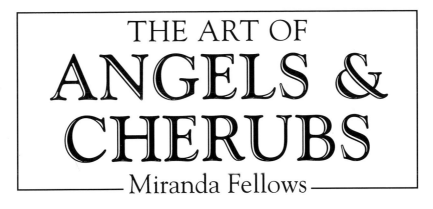

THE ART OF
ANGELS &
CHERUBS

Miranda Fellows

A Compilation of Works from the

BRIDGEMAN ART LIBRARY

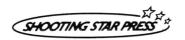

The Art of Angels and Cherubs

This edition printed for:
Shooting Star Press Inc.
230 Fifth Avenue – Suite 1212
New York, NY 10001

Shooting Star Press books are available at special discounts for bulk purchases for sales promotions, premiums, fund-raising, or educational use. Special edition or book excerpts can also be created to specification. For details contact: Special Sales Director, Shooting Star Press Inc., 230 Fifth Avenue, Suite 1212, New York, NY 10001

Printed in Italy

Editors:	Barbara Horn, Alexa Stace, Alison Stace, Tucker Slingsby Ltd and Jennifer Warner
Designers:	Robert Mathias • Pedro Prá-Lopez, Kingfisher Design Services
Typesetting/DTP:	Frances Prá-Lopez, Kingfisher Design Services
Picture Research:	Kathy Lockley

The publishers would like to thank Joanna Hartley at the Bridgeman Art Library for her invaluable help.

Angels and Cherubs

It is hard to imagine believing that angels ruled the universe, that they controlled gravity, could move stars and moons, that they could guard and protect us, or trick and deceive us. But there was a time when people thought it so, and described visitations by these celestial beings in elaborate words and vivid images. We have inherited this artistic legacy, one full of contradictions and repetitions, myth and magic. Following the path which angels have travelled is difficult yet rewarding, taking us on many rich diversions along the way.

The word 'angel' gives us a clue to its meaning. Derived from the Greek *angelos*, it meant 'shadow side of God', 'messenger' or 'revealer of truth'. Born before humans, angels are superior to them in intelligence and status. Angels were given free will by God – those who chose good were given a state of eternal grace, those who chose evil found themselves cast out of heaven into Hell. Angels have appeared in many religions, philosophies as well as in classical mythology.

To make the sense of all this clearer, we should consider the hierarchy to which angels are said to adhere. Although there are discrepancies between the theories pronounced, the general belief seems to be that angels exist within three heavenly zones.

In the highest reside Seraphim, Cherubim and Thrones. They are in direct communication with God. Cherubim have a single pair of blue wings, are often dressed in bishop's robes and are the relaters of knowledge. Seraphim have three pairs of red wings, four heads and carry flame-like swords. They emanate divine love. The Thrones are multi-eyed chariots or wheels which transport God's message. These angels are never in direct communication with humanity – they pass God's word to the second level, to the Powers and Virtues.

The Dominions, or Powers and Virtues, are the managers of all of the angels in heaven, and they guard the pearly gates. They communicate all messages from the first triad to the third, are hugely courageous and are often called brilliant or shining, like stars. They adhere to many a description of heavenly angels in their whiteness, brighter than any white known on earth. They can be good or evil, however, and one of their jobs is said to be the balancing of souls – the attempt to reconcile good and evil within humankind. These angels are said to be ruled by the Archangels, who exist in the third triad with the multitude of angels who filter God's messages down to humanity.

Who the Archangels actually are is hard to define, but for our purpose only six are really important – Gabriel, Michael, Metatron, Raphael, Uriel and Satanel, all of whom make regular appearance in Western art.

Metatron is often cited as the most important Archangel, the closest to God and the King of Angels, and one who seems to exist within many guises.

Michael himself is a far more substantial character than Metraton. As ruler of Israel, he is protector of God's Holy Land. He is also the judge of souls and leads them into heaven. He is said to have led the war against Satan when he rebelled in the Kingdom of Heaven, and is God's personal bodyguard.

Michael's most startling characteristics are visual ones, making him a favourite subject for painters of religious scenes. He is always ready for battle, so often appears in soldier's armour. His wings are significant in that they are made from peacock feathers. This has created many a myth.

Gabriel is the only archangel often depicted as a female. Gabriel was first mentioned 500 years before Michael and she is as central to Islam as to Christianity. She told Daniel of the coming of the Messiah, Zacharias of the arrival of St John the Baptist. When she appeared before Mohammed and revealed the Koran her wings stretched from east to west across the world. Most importantly to Christians, Gabriel told Mary of the Annunciation. Gabriel has saffron hair, yellow feet and jade green wings. She is often adorned with rubies and coral. In Islam the words, 'There is no God but God, and Mohammed is the Prophet of God' are emblazoned between her eyes. Often the easiest way to spot the Archangel Gabriel in religious art is to look for the white lily – the angel holding it will be her. It is the symbol of perpetual purity,

chastity and grace and she gave it to Mary at the Annunciation.

Archangel Raphael is the healer of humans and the doctor of the angels. He guards the Tree of Life and is usually shown with six wings.

We know what Satan symbolizes, but it is worth considering that he was not always a rebel angel and that he did have a role to play in Heaven before he incited revolt. If angels are like Satan, they are capable of evil.

As well as the Archangels, the third triad also contains the angels who communicate directly with humans. They are most human in their appearance and are vulnerable to misadventure.

The final angel we must mention is also the most chilling: the Angel of Death, who draws the soul out and steals it away. He is called Azrael. In classical mythology he has four faces and four pairs of wings, and his body is covered with eyes. It is said that when one blinks, a soul dies.

In painting, the characteristics of all of these angels are not always reproduced as described above. Cultural and social context and the change in artistic intentions over the centuries have affected the way in which angels have been depicted.

Cherubs are a classic example of this change. Originally they were seen as terrifying creatures – vile in appearance with many heads and bodies – who stood at the entrance to Paradise and guarded celestial palaces and kingdoms. But as time has passed their appearance has altered and become fixed in its Renaissance state, that of curly-haired babies with wings, musical instruments, the occasional bow and arrow. About the only suggestion of their more formidable past is apparent in their sometimes devilish expressions.

There was a time when the depiction of an angel was laden with meaning, its appearance in the stained glass of a church apse or on the frescoed ceiling of a palace or monastery protecting those who entered within. Now we admire them more for their decorative characteristics. Within these pages perhaps we may learn also to understand the subtleties which existed between them – and just what each artist, in his or her own personal way, was trying to tell us about the world they inhabited.

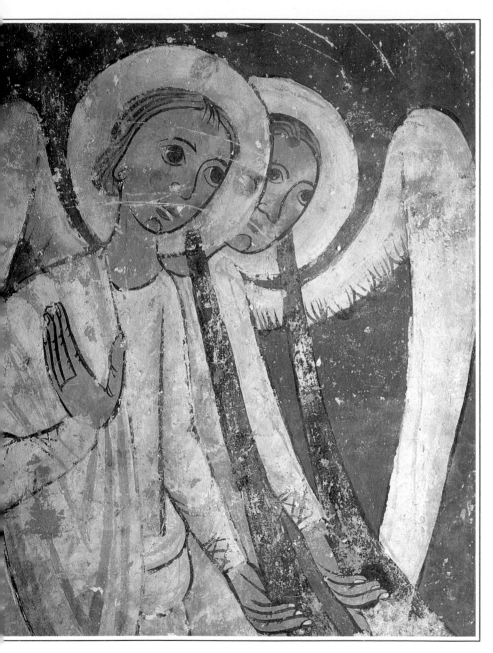

◁ **Mural from the Tomb of San Pablo de Casserres**
(detail showing angels with trumpets from the Last Judgement)
13th century
Pablo de Casserres

Fresco

THIS HEAVILY stylized and decorative painting of angels is characteristic of the Romanesque period when it was painted. Unlike later depictions of angels, which make them appear as human as possible, in Romanesque painting it was more common to depict them as decorative symbols. The shape of the body and the angle of the head are repeated from the first angel to the second to create pattern and rhythm. Their wings envelop them and they are crowned by halos – a characteristic not always adhered to in later examples.

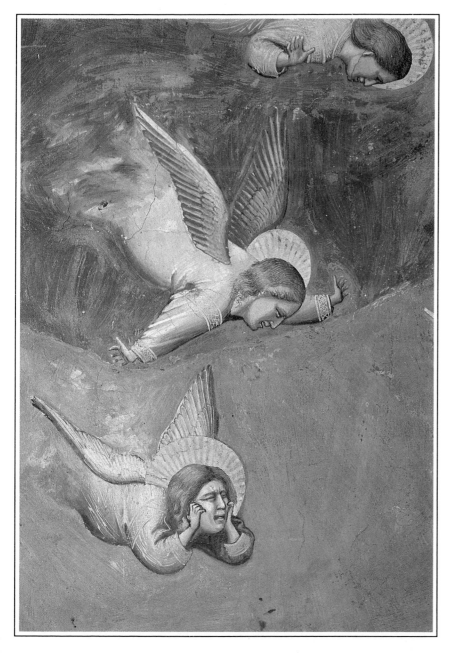

◁ **Angels from the Lamentation** c 1305
Ambrogio Bondone Giotto
(1266/7-1337)

Fresco

GIOTTO, FAMED FOR developing the basic principles of modern western art, here explores his new found skill at creating depth and perspective on the picture surface. These angels tumble happily through the illusion of space. Although they have human heads, wings are attached to their bodies, emphasizing that they are not human forms. It was commonly held at this time that angels had no forewarning of Christ's incarnation, passion or resurrection, so that all His experiences were as startling and unexpected to them as to humanity. They differed from humans in their unbending faith in all that He stood for and did.

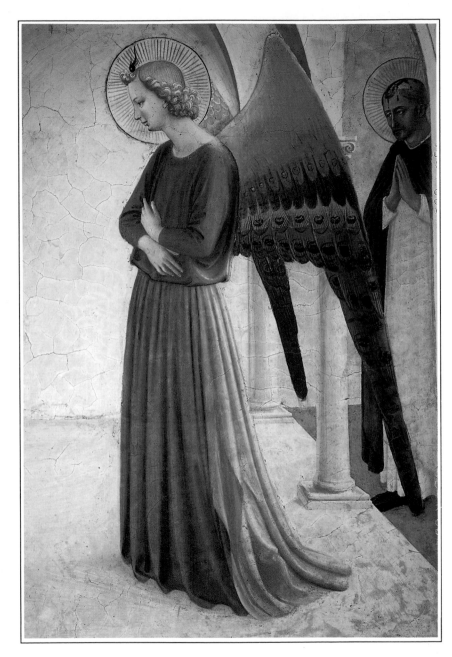

◁ **The Annunciation** c 1436
*(detail showing the Angel Gabriel, with
St Peter the Martyr behind)*
Fra Angelico c 1400-55

Fresco

As SERMONS, Fra Angelico's
paintings were simple and
instructive rather than elaborate
and mystical. He was influenced
by Giotto and the Gothic style,
and had a clear grasp of the
laws of perspective. Gabriel is
simply garmented, his hair
characteristically blonde and
styled in tight curls. He does not
hold lilies and gives no outward
sign of his purpose in coming to
see Mary. His is a serene, classical
poise, his halo and hidden feet
adding to the sense of his
lightness, enhanced by his wings.
It is worth noting that in this
image of the Annunciation,
Gabriel is adorned in identical
robes and with the same wings as
in another Annunciation scene by
Fra Angelica which hangs in
Museo di San Marco, Florence.

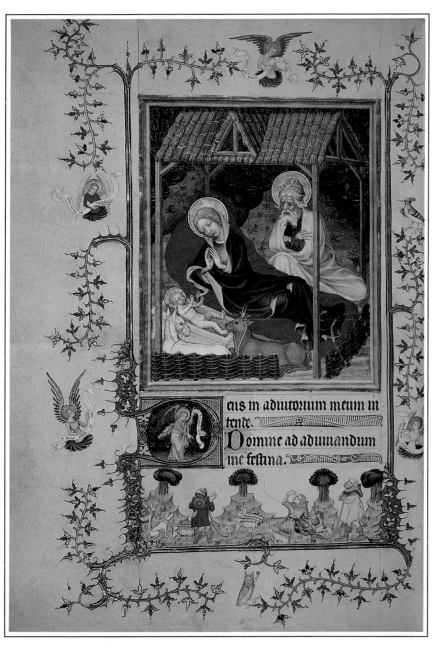

◁ The Nativity: Visitation of the Shepherds

from the Duc de Berry's *Très Belle Heures* c 1400–7

IT IS INTERESTING to see angels being used to decorate the border of an illuminated manuscript. They are separated from the main image of Mary, Joseph and Jesus by a frame, and from the shepherds and their flocks below by a golden bough. They come bearing the message of God on scrolls and are attached to the Tree of Life. As was common in early iconography, the angels and the shepherds are depicted as far smaller figures than the family, who are of central interest to the narrative. But the angels are celestial, and as such are separated from the shepherds by a second frame, to suggest their different realms. Their existence in the air rather than on earth is emphasized by the images of birds. Note how one cherubim, wings fiery red, is used as a purely decorative choice, sitting within the first calligraphic letter of the scriptures.

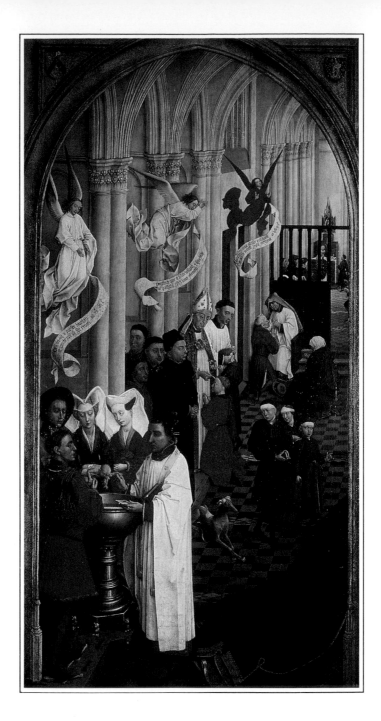

Detail

◁ **The Seven Sacraments** *(central panel of triptych)*
Roger van der Weyden (1399–1464)

Oil on canvas

VAN DER WEYDEN was one of the most highly regarded artists in Flanders in the 15th century, famed for his fine detail, humanism and high spiritualism. He tended to use brighter colours than his contemporaries: the white, yellow and red gowns of these angels are characteristic choices. He also concentrated on creating depth on the canvas, as is readily apparent here. The angels bear their messages on scrolls for the audience below to read: a common method used by artists to show angels presenting the word of God.

Detail

▷ **Madonna and Child Surrounded by Eight Angels** 1453-55
Marco Zoppo (1433-78)

Tempera on panel

THE CHERUBS which surround the Madonna and Child do not appear to be providing her with any messages from God, or giving guardianship against intrusion. Instead, they appear as churlish infants, more intent upon their own playful pursuits than her well-being! Here we have the classic early Renaissance emergence of the curly-haired cherub. They are a noisy bunch, playing musical instruments and twisting and turning around her. Their role is as decorative as it is narrative, they help create a frame around the mother and child. Their wings have become tiny, their halos have gone. Their spiritual significance has been lessened in favour of the artist's humanist depiction.

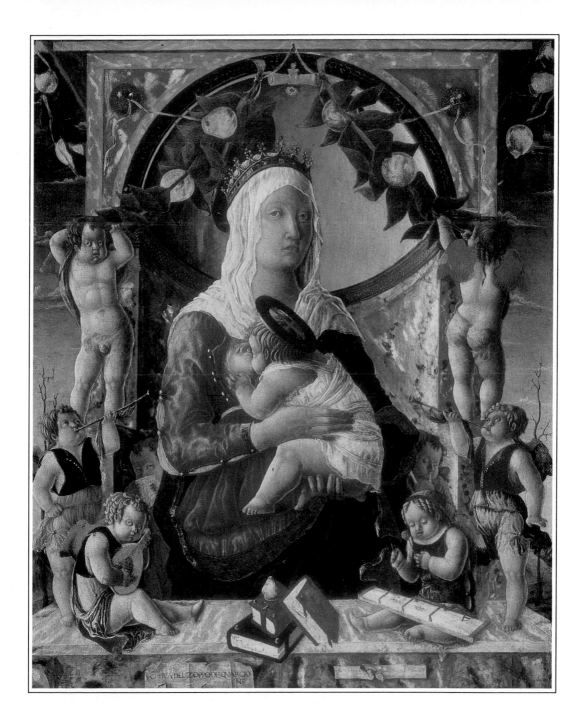

Detail

▷ **The Three Angels and Tobias**
Francesco Botticini (1446-97)

NOT RECOGNIZED for his individuality of style, Botticini nevertheless learned much from his mentors, who included Botticelli and Filipino Lippi. This painting demonstrates how he would use artistic licence in the creation of a scene. Tobias was met by the Archangel Raphael alone, but here, for want, we presume, of further decoration, he has been joined by fellow angels Gabriel and Michael. But Raphael seems to sport Michael's peacock wings, presumably in an attempt to embellish him further. Michael, to the left, carries his unsheathed sword, and Gabriel, to the right, the characteristic lily, symbol of chastity.

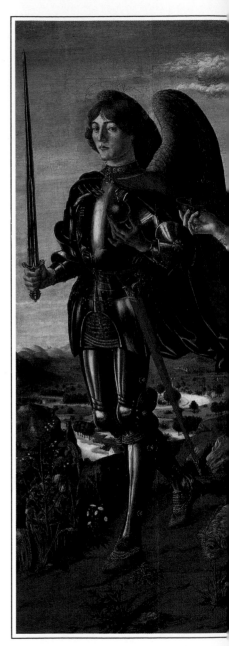

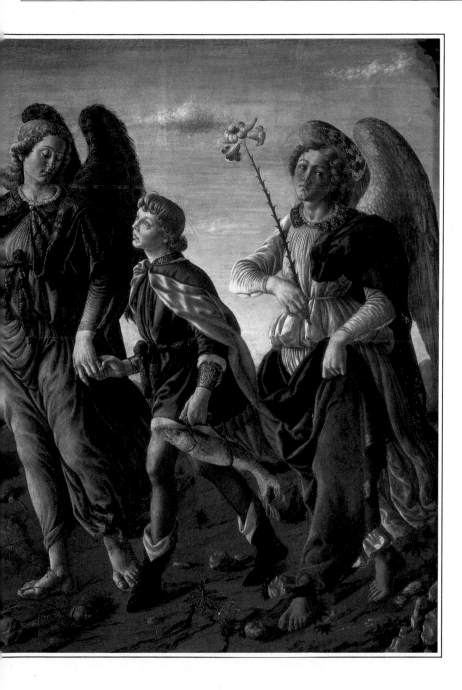

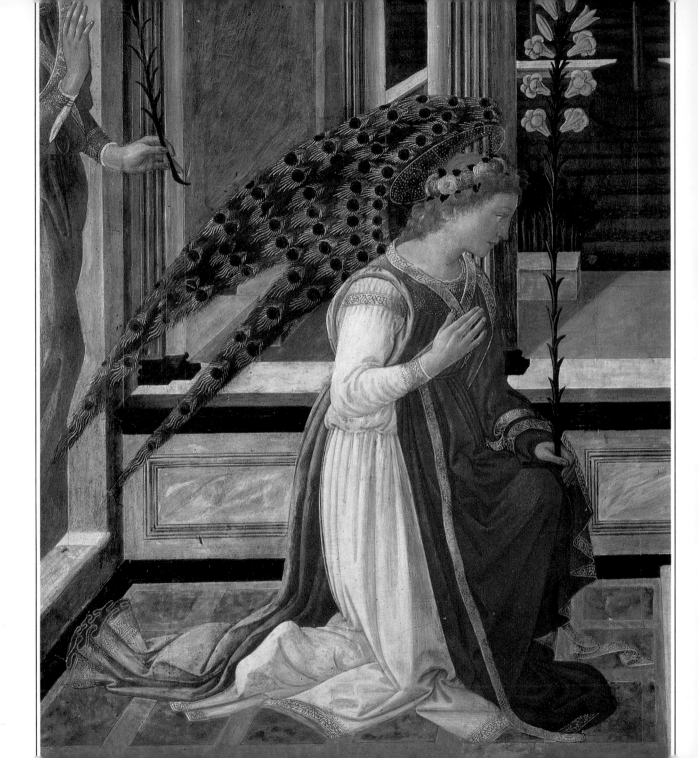

Detail

◁ **The Annunciation** *(detail)*
Filippino Lippi (1457/8-1504)

Fresco

LIPPI WAS FORTUNATE to be
Botticelli's assistant and from him
he learned to articulate line and
colour with an unusual deftness
and skill. This Annunciation scene
demonstrates the master's skill of
rendering. Note how it is now
Gabriel who is fortunate enough
to have peacock feather wings,
and how the flowers in his hair,
crown a bent and modest head.
The origin of the lily, symbol of
chastity and purity, is said to be
the Garden of Eden. When Eve
was expelled, it is said that she
cried tears which fell to the
ground and grew into lilies.

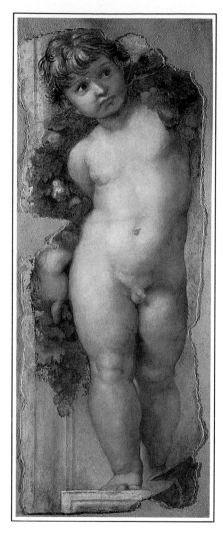

◁ **Putto with Festoon**
(fresco fragment)
Raphael Sanzio of Urbino
(1483-1520)

Fresco

THE SIMPLE, perfect face and form of the putto (cherub) is reflective of Raphael's fluency as a High Renaissance master. The innocent eyes and freshness of the flesh, combined with the contrapposto of the body and the naturalistic golden locks, are a celebration of his simple yet perfectly balanced style. The cherub does not have any wings to speak of in this image. High Renaissance painters often omitted halos and wings for the sake of balance and harmony.

▷ **The Sistine Madonna**
Raphael Sanzio of Urbino
(1483-1520)

THE SISTINE MADONNA is one of the few works by Raphael which is said to have been executed entirely by the master's own hand. Considering how busy he was with commissions, the reason why he spent so much time on it is a matter for conjecture. The cherubs emphasize the heavenly state within which Raphael has placed the Madonna. Her image has come a long way from early depictions of her as a normal peasant girl endowed with the greatest gift from God. Here, she is Mother of God, raised triumphantly on high. The image is simple and light, the two cherubs adding a touch of humour to an otherwise austere religious scene.

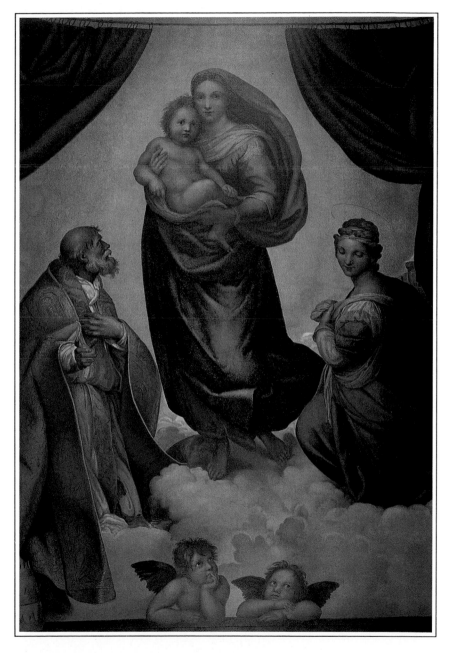

Detail

▷ **Madonna and Child with St John the Baptist**
Giovanni Battista (Fiorentino) Rosso (1494-1540)

Oil on canvas

IN THIS LATE Renaissance painting, it is not the cherubs who have halos but the Madonna, Christ and John the Baptist. They add decoration and a reflection, perhaps, of the youthfulness of the boy Christ. One of the founding artists of Mannerism, this work still shows all of the signs of a classical training, yet with the beginnings of an expressionism showing in the faces of the figures.

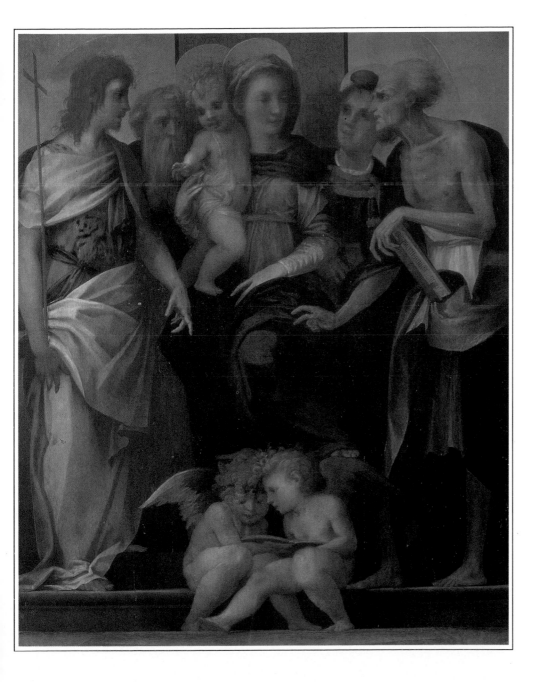

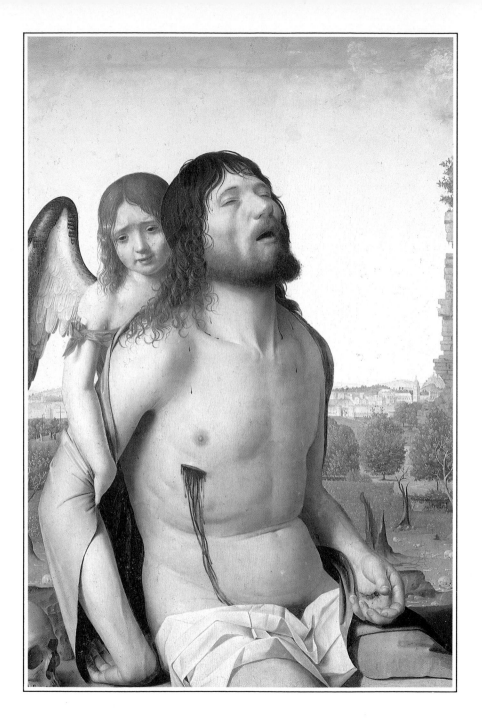

Detail

◁ **The Dead Christ Supported by an Angel**
Antonello da Messina (1430-79)

THE MOTIF of angels supporting Christ was first introduced by Donatello, but re-emerged in the hand of Zoppo, Crivelli, Bellini, and as we see here, Messina. The single angel expresses Christ's agony by his downcast eyes and mouth, in contrast to Christ's head which is tilted heavenward in its mortal pain. The skull by the angel's foot represents Christ's imminent Ascension, and by holding onto him from behind, the angel is supporting his soul. The narrative is set against a classical backdrop, a tableau of the countryside, strewn with further skulls and bones.

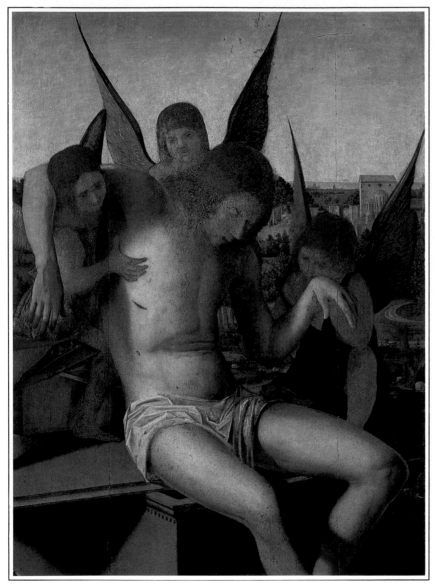

◁ **Pieta**
Antonello da Messina (1430-79)

AGAIN, MESSINA concentrates on the image of Christ being supported by angels, but here, unlike in the previous example, there are three. The image is far less detailed and more muted in tone than before. Christ's head is hung low and the three angels support and surround him, their wings suggesting the journey he is about to take upwards to Heaven. The positioning of Christ renders him leaden in weight and the angels really appear to be straining to support him. Again, skulls and bones strew the distant landscape.

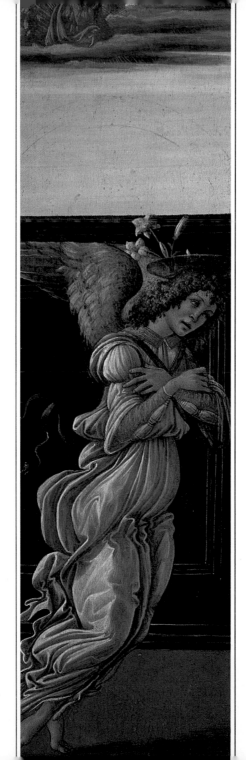

◁ **Archangel Gabriel**
Sandro Botticelli (1444/5-1510)

Fresco

BOTTICELLI'S DEPICTION of the
Archangel Gabriel descending to
tell Mary of her expected child is
a mastery of grace and gesture,
fine line and intricate detail.
Gabriel is seen dramatically
floating in his flowing garments,
his hair a wave of saffron curls, his
wings glorious and golden. And
from his crown sprouts his symbol
of chastity – the lily flower. He is
an arresting figure. In this
painting it is easy to see why the
Pre-Raphaelites so admired
Botticelli's classical style.

Detail

▷ **Vallombrosa altarpiece** *(detail of angel musicians)*
Pietro Perugino (1445-1523)

THE CLARITY of Perugino's design was much celebrated in his lifetime and it is widely believed that he helped pave the way towards the High Renaissance with his clarity, balance and ordered compositions. It is interesting to see an image in which the angels are not all depicted as human forms with wings. Although the cherubs have baby faces, they have no bodies. As St Thomas Aquinas had deduced that angels were pure intelligences, not united bodies, and as intelligence lies in the head, this was the most important part. The more human angel musicians come from the lowest triad and their music would be used to pass on the messages of the cherubs, who had heard them direct from God. They would have believed that music would help relay their messages to man more clearly. The angel at the bottom of the composition appears to be carrying a child – perhaps she is a symbol for the Virgin mother.

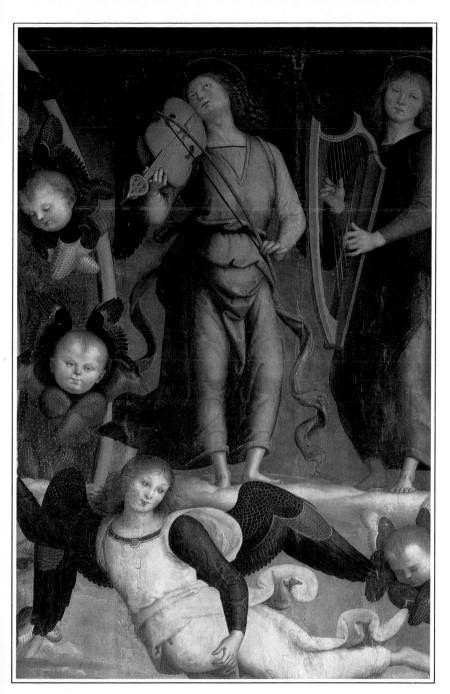

The Annunciation
Leonardo da Vinci (1452-1519)

Oil and tempera on a wood panel

▷ *Overleaf pages 30-31*

ONLY FORMALLY attributed to Leonardo in 1939, this is an early work and is far more stylized and less confident than later paintings. The outdoor setting is unusual for Leonardo, but the walled garden is said to symbolize virginity, as does the lily. In contrast to earlier artists' interpretations of the angel, which tend to give him superhuman qualities, Leonardo's Gabriel is distinctly human, if androgynous in appearance, denoting the new concentration on humanism in religious iconography. His wings are carefully contrived to appear bird-like and natural. There are several examples of angels in Leonardo's work, but during this period their popularity was waning, due to overexposure in religious painting of the Renaissance.

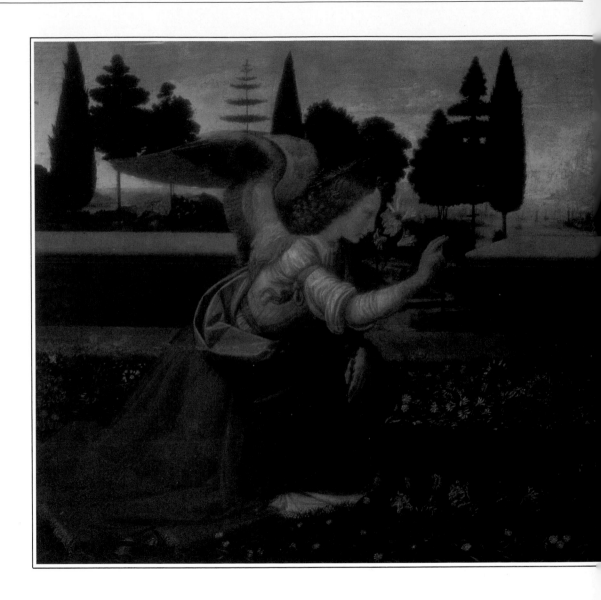

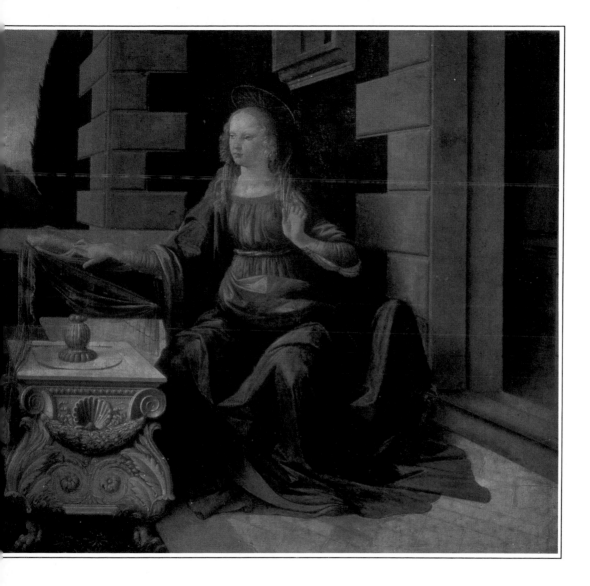

△ **Angel Playing the Lute**
Giovanni Battista (Fiorentino) Rosso (1494-1540)

Oil on canvas

THERE IS A SOFT, surreal quality to this painting, common to the work of Rosso. The figure is emotive and sensual, the setting is irrelevant, the sheer pleasure that the angel gains in playing his musical instrument is of central importance to the image. The angel of music is generally accepted as being Uriel, and this was probably meant to be one of his choir rather than himself. Music was believed to be the angelic art – deriving from the heavens and raising people into a spiritual consciousness unlike their day-to-day experience. It was also believed that music aided us in our understanding of the higher language of the celestial beings.

▷ **The Mystic Nativity**
Sandro Botticelli (1444/5-1510)

Oil on canvas

BOTTICELLI'S SCENE celebrates the birth of Christ and the triumph of good over the evil of Satan's reign on earth. The Nativity story is taken from St Luke's Gospel, Chapter 2, where the birth of Christ marks the beginning of a reign of peace. All of the angels are carrying olive branches, as a sign of this new-found utopia. Those above the stable are dancing in celebration, those in the middle are leading the shepherds to Christ and the three in the foreground are embracing man at this moment of reconciliation. Note how the devils are writhing in agony on the ground at their loss of power.

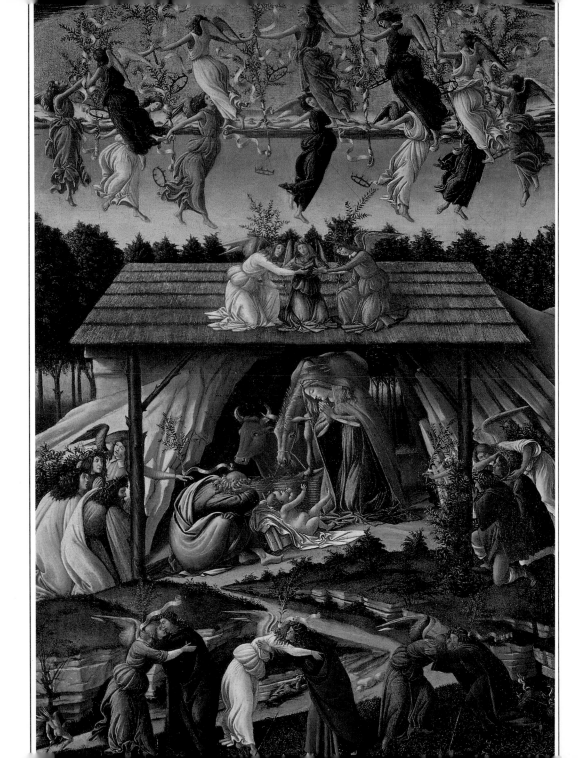

Detail

▷ **Madonna and Child**
David Gerard (1460-1523)

Oil on canvas

VAN DER WEYDEN and Memlinc are the unquestioned influences on this artist of the Netherlands. The angels are used as a decorative device to crown the Madonna and give her a spiritual dimension. They are typically northern in their appearance. It was common for artists of the 15th century to paint angels with distinctly human qualities, with wings but no halos. They were usually reduced in size to differentiate them from the human species. Note the elaborate detailing Gerard has created in the crown, ensuring the superiority of the Madonna.

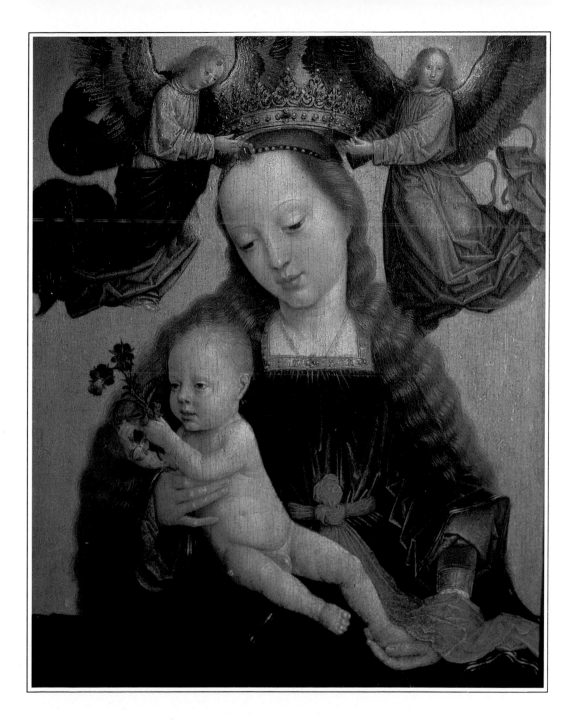

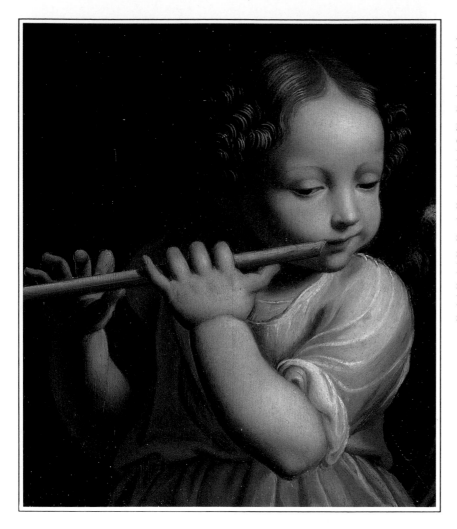

◁ **Child Angel Playing a Flute** c 1500
Bernardino Luini (1480-1532)

DURING HIS LIFETIME, such images
as this Child Angel gained Luini
great popularity in his home town
of Milan. An avid follower of
Leonardo da Vinci, one can see
how he took his mentor's example
to the extreme – the image is
slightly mannered, the purity of
the angel lost to a certain self-
satisfied air which renders it
slightly comical and aspiritual.
Humanism is taken to its extreme,
so much so that there is little room
left in the painting for the
superhuman experience to unfold.

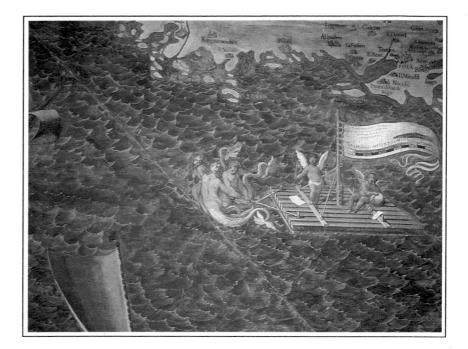

△ **A Raft of Cherubs** *(detail)*
Danti, Egnazio (1536-86)

THIS DETAIL IS taken from the Gallery of Maps, in Rome, commissioned by Pope Gregory XIII between 1580-83. It is unusual to see angels appearing in a cartographer's art, but nevertheless here is evidence of one rare Renaissance occasion. The map is held in the Vatican and perhaps the inclusion of spirits offered it a necessary religiosity. It is probably more likely that, by the time of the map's creation, cherubs had become little more than decorative and popular icons in Roman culture and were included, along with a mermaid, to add life and vitality to the scene, bringing messages of human kind from foreign climes. They certainly succeed.

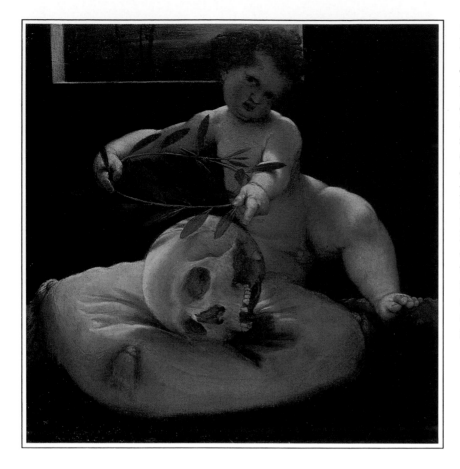

◁ **Cherub with a Skull**
Lorenzo Lotto (1480-1556)

THIS IS AN unusual composition, but its horizontal position is common to Lotto. An eclectic artist, he never established a striking personal style, but in this example the artist has succeed in creating a chilling and thought-provoking image. The cherub ironically places a 'crown' around the skull of a dead man. His face holds a discreet and unsettling expression, this cherub is one whom we may not feel we could trust upon meeting. He is perhaps a messenger of Azrael, the Angel of Death, bringing to earth the message of mortality.

▷ The Isenheim Altarpiece
(detail)
Mathis Grünewald (1470/80-1528)

THERE ARE FEW religious works revered so much as this altarpiece, from which this detail of the Angel Gabriel is taken. Grünewald was a high Gothic artist who had an understanding of Renaissance classicism and the laws of perspective, yet chose to imbue his paintings with intense emotion and colours more in keeping with his northern roots. Gabriel here is a glorious yet imposing figure, talking emphatically to the Madonna, passing on God's message of the immaculate conception. His hair is the colour of saffron, as tradition decreed, and he is depicted with an intense humanism. The book Mary holds open on her knee is likely to be Isaiah, Chapter 29, verses eleven and twelve, which contain the words: 'behold, a virgin shall conceive'.

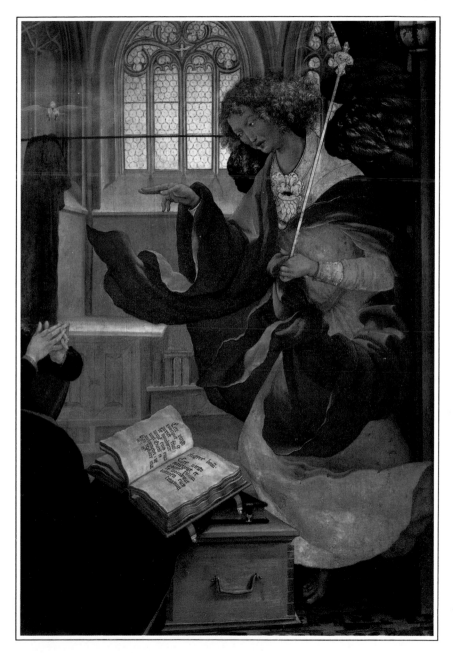

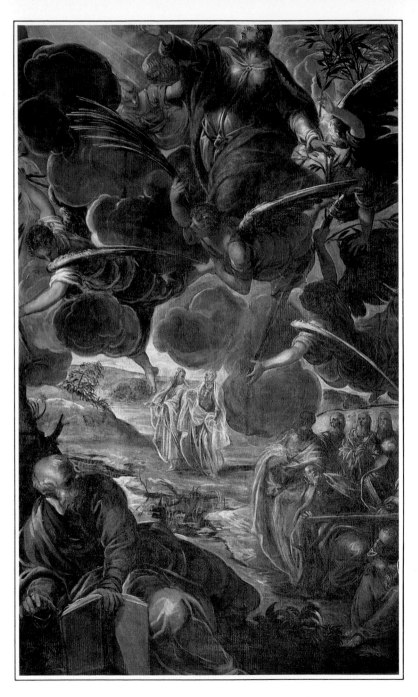

▷ **The Ascension of Christ**
Jacopo Tintoretto (1518-94)

THE RADICAL, anti-Classical style developed by Tintoretto in Venice during the 16th century marked a turning point in High Renaissance art. Tintoretto stole the limelight from the school of Titian with his rejection of naturalism in exchange for the drama of expressionism – through which Mannerism was born. This fresco was painted late in his career, 1576-81. It was the last of ten wall paintings which decorated the ceiling of the Sculoa di San Rocco, Venice. The angels' wings create repetitive rhythms and spatial dynamism. They frame the figures of Christ and the disciples as a picture within a picture, a dramatic encounter between the spiritual world of angels and the physical one of humanity.

▷ **Putto with a Red Flower**
Paolo Veronese (1528-88)

HERE WE SEE a putto (cherub) of classical nature – a Renaissance device to which we still assume accuracy today. Veronese was a Venetian who chose to follow Titian in preference to the new Mannerism of Tintoretto. The cherub is nature incarnate: fresh-fleshed and curly-haired, softly curving around the scene. The form is fluent and appealing, but there is little evidence of emotion for the viewer to share in.

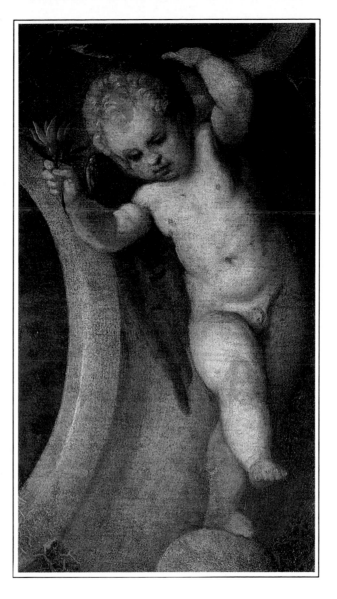

Detail

▷ **Madonna Carried by Angels**
Jacopo Palma (Il Giovane) (1544-1628)

PALMA MAY HAVE been invigorated by the colours and Classical forms of Titian, but this prolific Venetian was a Mannerist in mood and composition. The marriage of the two schools within this ceiling fresco creates a beguiling image. The Madonna is a vision of serenity itself, yet her impassive features contrast with the drama of the scene enveloping her. The cherubs lift her on high, creating a repetitive and decorative motif which raises her towards heaven. The light source appears to emanate from behind, yet the Madonna's face is illuminated, in dramatic contrast to her dark and billowing robes, within which float the cherubs.

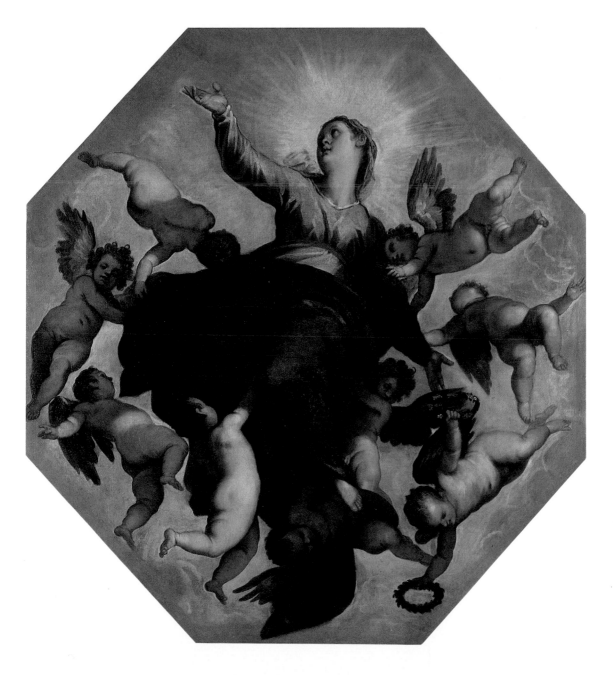

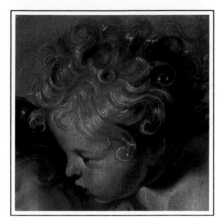

Detail

▷ **The Annunciation**
Peter Paul Rubens (1577-1640)

THE UNDEBATED master of Northern Baroque, Rubens honed his skills as a young painter in Italy. High drama imbues this Annunciation scene. Note how Gabriel's golden locks catch the light, how the Madonna's hand lies poised to turn the page of her scriptures. The detailed execution includes the carving of an angel in the piece of furniture by which she stands, denoting human adulation of the spiritual life. Cherubs, which adorn the ceiling, emphasize the heavenly nature of Gabriel's visitation and also confirm the influence upon Rubens of Carravaggio and other Renaissance masters.

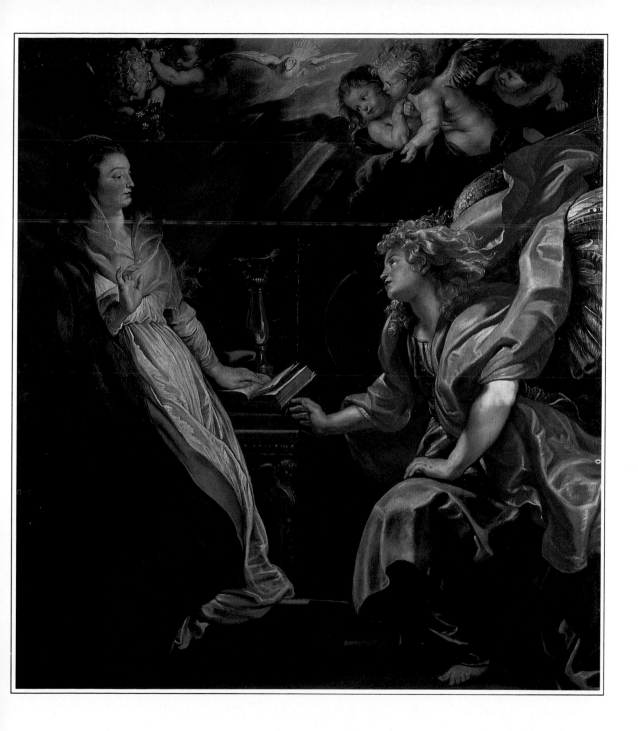

Detail

▷ **Annunciation**
El Greco (Domenikos Theotocopoulos) (1541-1614)

EL GRECO'S religious vision adorns churches and monasteries throughout the medieval Spanish city of Toledo. His use of lime greens and cerulean blues, sharp pinks and lemon yellows retain their vibrance on his frescoes even today. High drama, light and colour denote a rejection of the Classical and confirm his early Venetian training in the Mannerist style. Note how Gabriel's limbs are elongated to express weightlessness, how elaborate the composition has become, how the actual story of the Annunciation is almost secondary to the climactic nature of the experience, emphasized by the cherubs who serve no narrative purpose yet proliferate, drawing our eyes upwards towards the angelic choir, making their spiritually uplifting music on high. Rhythm percolates down and into the forms of the main figures beneath, where Gabriel is gowned simply in green to contrast with the Titianesque crimson of Mary's shining robes.

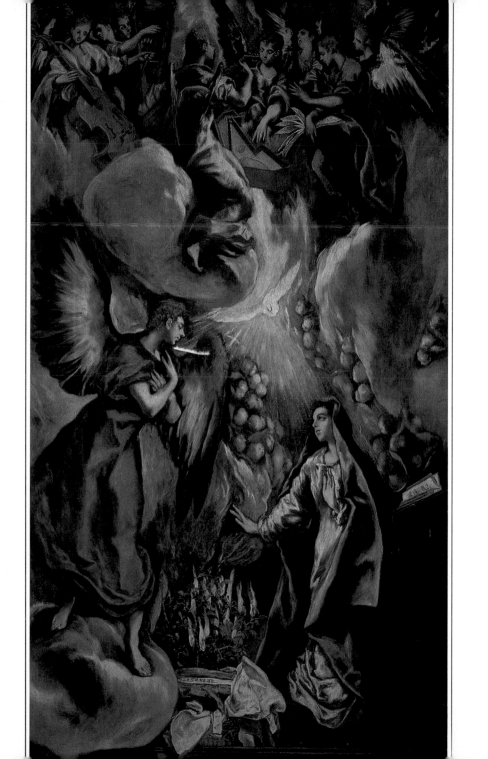

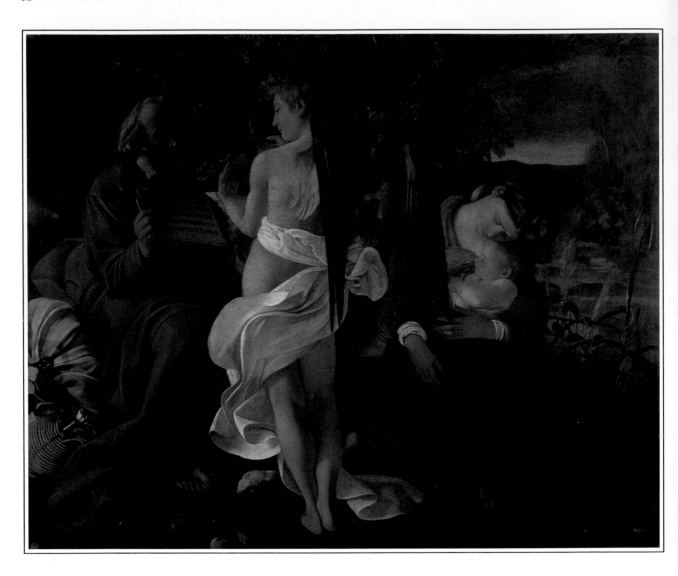

◁ **Flight Into Egypt**
Michelangelo Carravaggio
(1573-1610)

THIS UNUSUAL IMAGE shows the back of an angel playing a violin to Joseph's music, allowing the viewer a splendid view of his wings. These, in their realistic depiction, are closer in their association to birds than spirits. Carravaggio, Leonardo da Vinci and Botticelli all used birds such as geese, swans and eagles as reference in their painting of angels' wings. Carravaggio was much criticized during his lifetime for his vivid realism, for not idealizing religious subjects. As here, he clothed the figures in contemporary peasant dress. He did not create the Virgin and Child as goddess and little prince, but rather as mother and son, fatigued from their enforced flight out of Bethlehem after Herod had ordered the murder of all infant boys under the age of two. The angel is unrobed, other than for his classical drapes, and has more the appearance of a young shepherd boy than a messenger from God. He probably represents Gabriel. The chiaroscuro effects of starkly contrasting light and dark are characteristic of Carravaggio's style, in which beauty and truth in nature were the fundamental objectives.

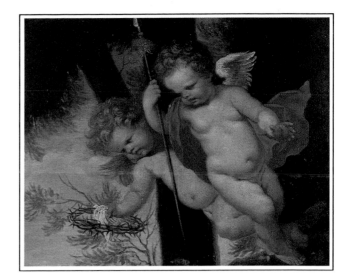

△ **Two Flying Cherubs Holding the Crown of Thorns and the Spear of Longimus**
Andrea Podesta Giovanni (1620-74)

IN THIS BAROQUE painting of cherubs, Giovanni depicts them removing two symbols of man's lack of faith in Christ. The crown of thorns was placed on Christ's head in mockery by Pilate's soldiers. St Longimus was the soldier in the gospel of St John who wounded Christ in his side with a spear. He was said to be blind, and, after the event, upon rubbing his eyes with his blood-smeared hands, he regained his vision.

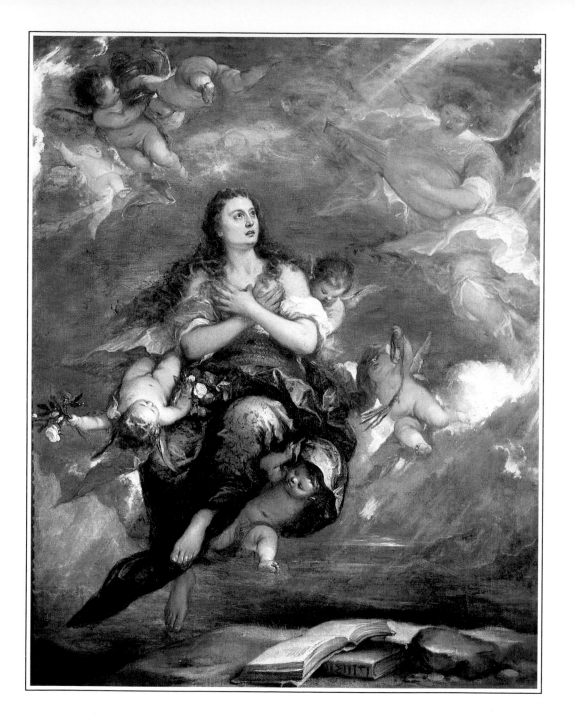

Detail

◁ **The Assumption of Mary Magdalene**
José Antolinez (1635-75)

TYPICALLY flamboyant in style, the bright blues and strong lighting make Mary's assumption both theatrical and regal. The cherubs are carrying Mary's body and soul to God – note Uriel, with his musical instrument providing her with a sweet tune to accompany her on her journey.

Detail

▷ **The Holy Family**
Hermensz van Rijn Rembrandt (1606-69)

Oil on canvas

THIS SCENE SHOWS the Holy Family as lowly subjects, Mary sits cradling Jesus while Joseph chops wood. The figures are in no way glorified but the whole scene is imbued with Rembrandt's golden light. The cherubs, watching over the Madonna and Child, add a spiritual dimension to an otherwise sombre scene. Their heavenly glow links the simple family to the celestial world from which they come.

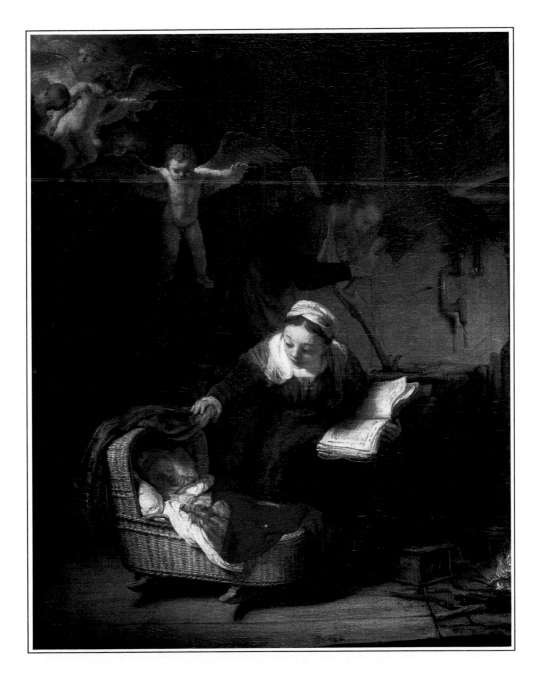

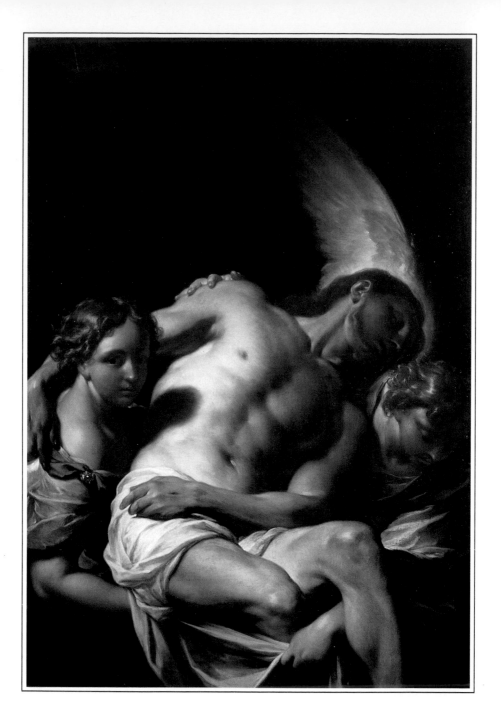

Detail

◁ **Christ Supported by Angels**
Francesco Trevisani (1656-1746)

TREVISANI WAS born in Naples and active in Rome from 1678. In this highly theatrical Baroque painting, the paradox of agony and ecstasy in Christ's death is painstakingly portrayed. The image holds an overwhelming emotional appeal, with strong chiaroscuro, balance and harmony. The two idyllic child angels wear one blue, one red gown – linking them to the traditional symbols of cherubim and seraphim who have blue and red wings, respectively.

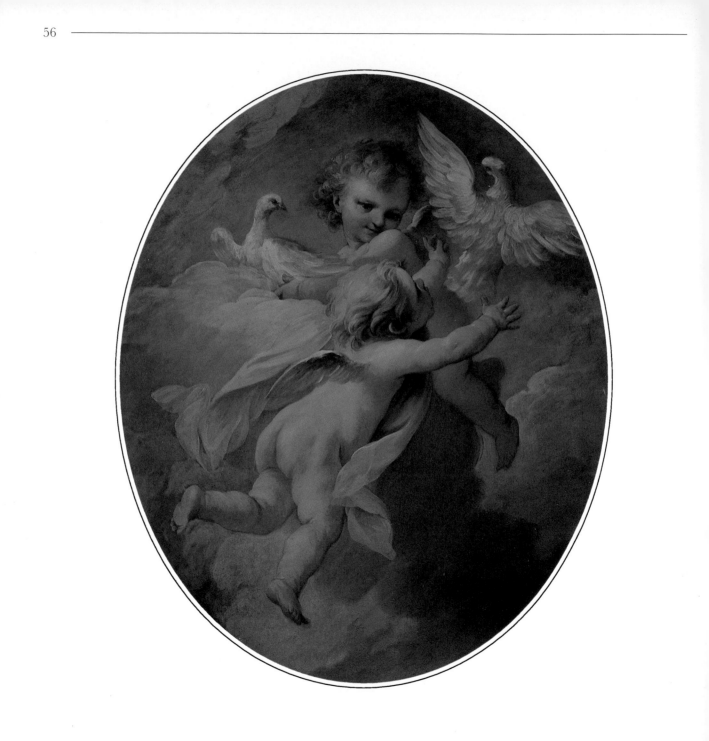

◁ **Angels and Doves**
François Boucher (1703-70)

Oil on canvas

BOUCHER IS ONE of the most celebrated of Rococo artists – a famous painter of baby cherubs. He relished exuberance, sensuality and artificiality in his paintings, striving to achieve the impression of an idealized, perfect world. The wings of the cherubs are as soft and downy as the feathers on the doves, their skin as pink and fresh as a newborn baby's – yet they have adult, characterful faces. Innocence is mixed with adult knowledge in this provocatively sensual scene.

▷ **The Annunciation**
c 1757-62
Giovanni-Battista Tiepolo (1696-1770)

Fresco

UNLIKE HIS MORE Rococo paintings, Tiepolo's pen and ink drawing is simplicity itself. It is a spiritually uplifting image of Gabriel, gesturing heavenward to Mary, whose figure is hunched in humility, her head covered by a scarf. This drawing is all light and line, and offers an unadorned view of the Annunciation.

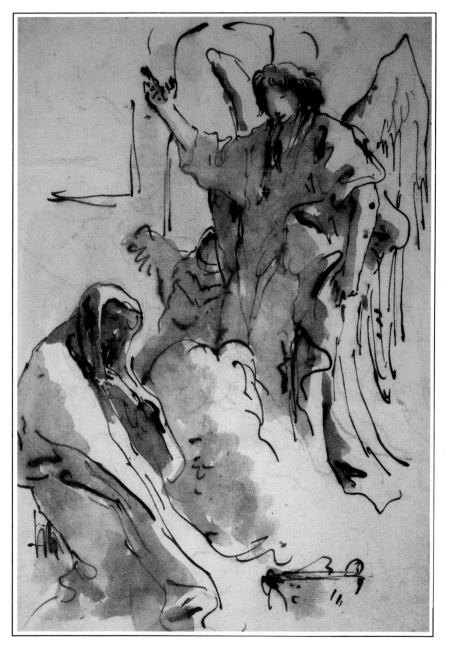

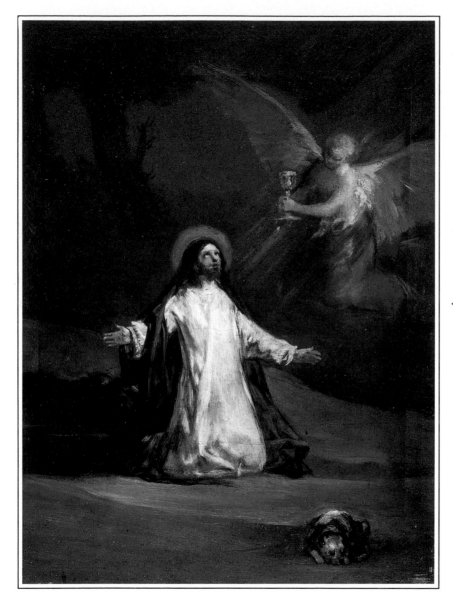

◁ The Agony in the Garden

Francisco Jose de Goya
y Lucientes (1746-1828)

Oil on canvas

PAINTED LATE IN Goya's life, after serious illness, this picture shows all the signs of the artist's own horrific nightmares and visions. Christ's eyes are wide and white, almost unseeing. The angel is holding the cup of salvation from which the guilty must drink before being allowed to ascend to heaven. Rather than the three disciples who are said to have accompanied Jesus to the garden of Gethsemane, Jesus has only one companion: a faithful dog.

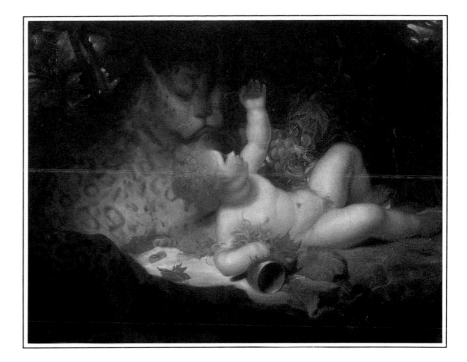

△ **Cupid on Guard**
Thomas Stothard (1755-1834)

Oil on canvas

THE LEOPARD IS the symbol of sin and destruction, as we can learn from the words in the Book of Revelations: 'And the beast I saw was like unto a leopard'. Chammel, the Duke of Hell, was also sometimes portrayed as a leopard. He was the ruler of Mars, the evil planet of war. Cupid is seen here, as a cherub, entertaining Mars.

Detail

▷ **Christ in the Sepulchre, Guarded by Angels**
William Blake (1757-1827)

CHRIST IS enshrined in the same cloth which robes the angels, linking his mortal body to their spiritual life. Blake often painted angels and exploited the shape of their wings to create highly decorative scenes. The painting is simple, beautiful and mystical, the light which permeates between the parallel wings of the angels symbolizing Christ's ascension. One angel is male, one female, and their earthly, naked forms are perceptible beneath the pale muslin cloth.

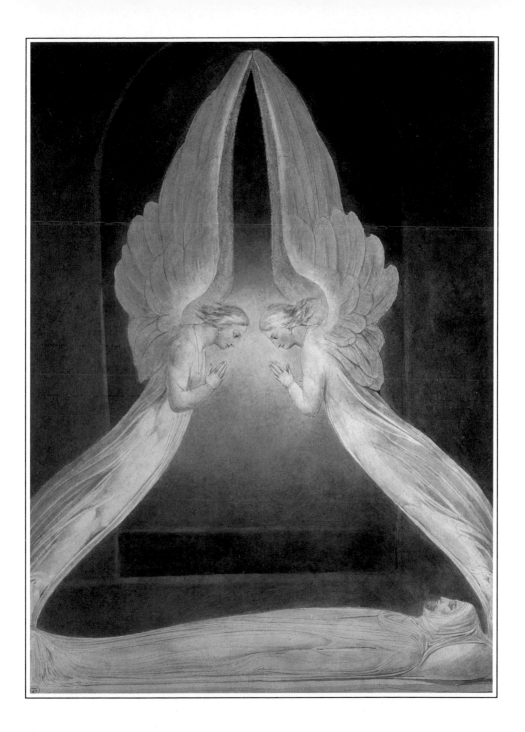

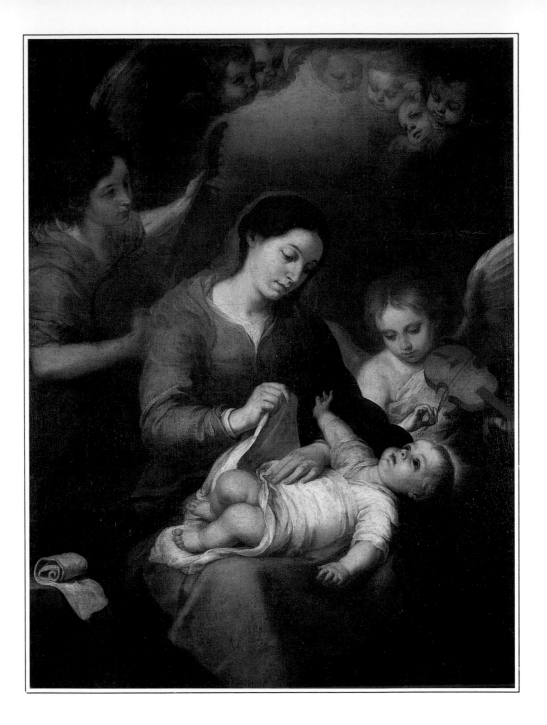

Detail

◁ **Madonna Wrapping the Christ Child in Swaddling Clothes**
Bartoleme Esteban Murillo (1617-82)

Oil on canvas

MURILLO WAS BORN and lived in Seville. He was a realist in his depiction of figures, but was greatly influenced by the northern Baroque. There is genuine warmth and sensitivity in this portrayal of the Madonna and child, and they have distinctly human features – as do the two musical angels playing to them. This is an emotive scene in which the cherubs, who are winged but have no bodies, crown the Madonna and emanate a heavenly light.

Detail

▷ **Swarms of Cherubs, a Group of Children in the Sky**
Jean-Honoré Fragonard (1732-1806)

Oil on canvas

FRAGONARD'S CHERUBS are in competition with Boucher's for their sickly sweetness. In fact, Fragonard studied under Boucher and was another exponent of the French Rococo style. Anti-realism rules on high. The cherubs dominate the sky, tumbling softly through the clouds like balls of pink and white cotton wool in a lady's toilette. They are ornaments with little religious significance, and the picture's title, equating cherubs with children, denotes the fine line which Fragonard has happily crossed between religious symbolism and a purely decorative art.

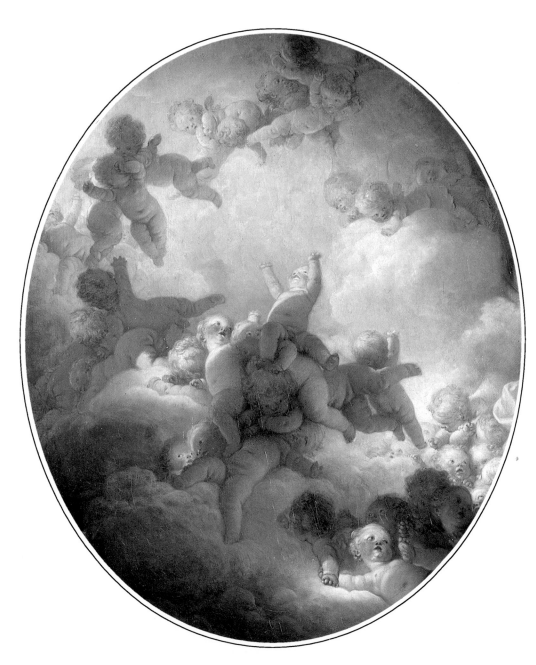

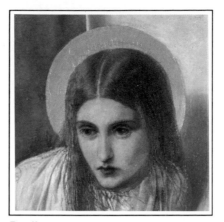

Detail

▷ **Ecce Ancillia Domini, The Annunciation**
Dante Gabriel Rossetti (1828-82)

Oil on canvas

IN THIS MODERN portrayal, Gabriel appears floating on a golden cloud appealing to the Madonna – the epitome of medieval beauty with her long red hair, tinted white skin, deep set eyes and blood-red lips. As Christina Rossetti said of her brother's paintings:

One face looks out from all his
 canvases...
One self-same figure sits, or walks
 or leans,
Not as she is, but as she fills his
 dreams.

The Pre-Raphaelites strove to portray the ideal of medieval beauty on the canvas. The image is based on Rossetti's wife, Elizabeth Siddal. The Madonna is innocent yet sensual, Gabriel is unwinged, although he has a halo, and he appears to Mary in her bed-chamber at the moment of conception.

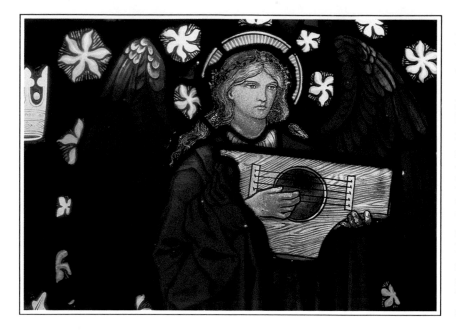

▷ **The Dream of St Cecilia**
Paul Baudry (1826-86)

Oil on canvas

ST CECILIA was forced to marry but she made her husband vow to respect her chastity. If he did not, she warned him, the angel who watched over her would punish him. St Cecilia's Day is a celebration of music, hence all of the angels who appear here carry musical instruments. This Baroque painting makes full use of spatial dimensions and the angels are garbed in classical robes. The image is full of drama and emotion.

△ **The Angel Musician**
Edward Burne-Jones (1833-98)

Stained glass (for William Morris & Co)

THE PRE-RAPHAELITE and Arts and Crafts Movements worked hand in hand, and this stained glass window was commissioned by the latter, in the form of William Morris & Company, to a member of the former. It is a dreamy, romantic image, showing the influence of Mantegna and Botticelli on Burne-Jones. He was more influenced by Renaissance art than his friend Rossetti, and was interested in representing images through flat colour and simplified form. The Angel of Music is probably Uriel. Here, his finely drawn face and musical instrument contrast with the decorative red glass of his robes and wings, and the repeated pattern of flowers which provide a background.

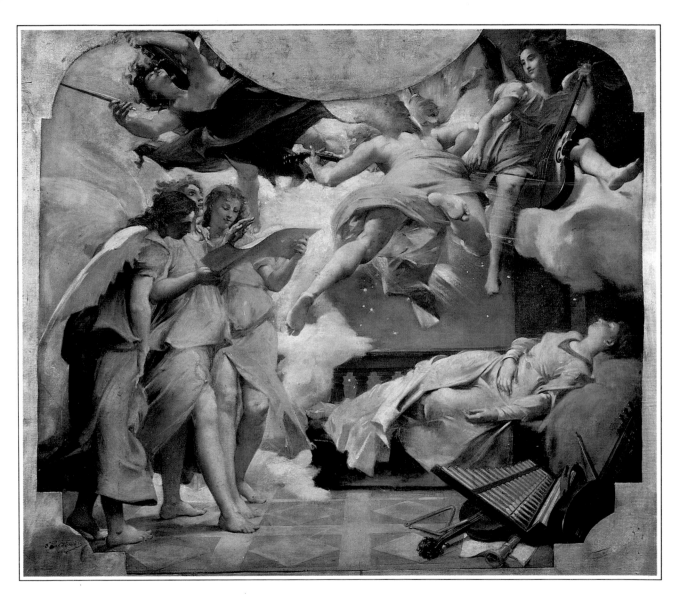

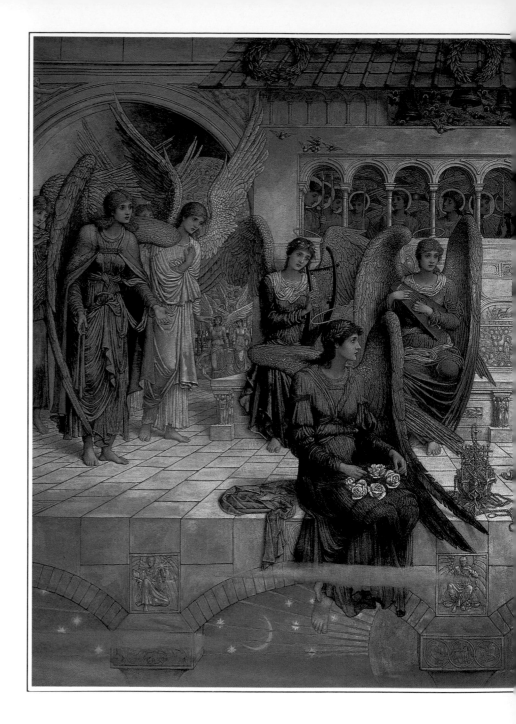

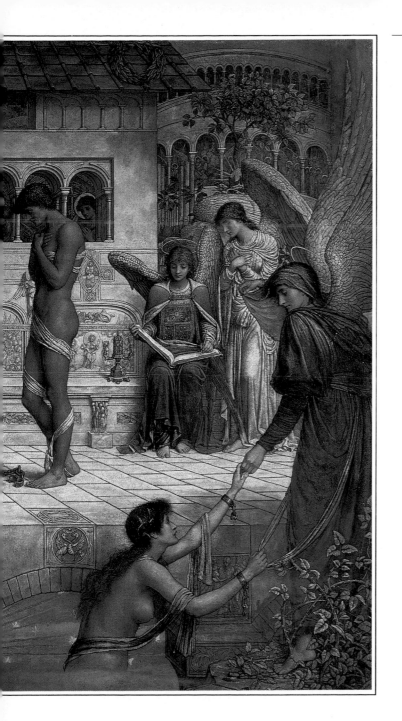

◁ **The Ramparts of God's House**
John Melhuish Stradwick
(1849-1937)

Oil and gold leaf on canvas

THIS IMAGE IS steeped in
romantic medievalism, the angels
garbed in gold and silver, their
wings large and finely detailed,
their halos shining. The paint
surface is richly encrusted.
Stradwick was one of the last
upholders of the Pre-Raphaelite
tradition. His figures are
characteristically tall and slender
and the elaborate style is
particular to him. The angels are
Pre-Raphaelite maidens – very
much female figures rather than
celestial beings. Their clothes are
so classical that they could almost
be carved from stone, as are
replicas of them in the ramparts.
The building in which they reside
is so heavily influenced by the
Arts and Crafts movement that it
could have been designed by
William Morris. Angels fill every
nook and cranny, as befits the
House of God.

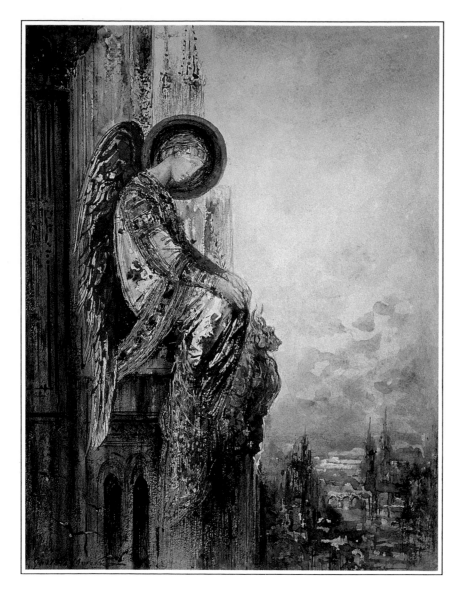

◁ **Angel Traveller**
Gustave Moreau (1826-96)

Oil on canvas

GUSTAVE MOREAU painted many religious scenes and allegories in a highly elaborate, finely detailed style. The leader of the Symbolist movement, he impasted his oil onto the canvas until the surface was encrusted with paint. This is a fine example, the angel is elaborately executed, with long, elegant wings and gold threads woven in his robes. His figure is boyish yet refined, and he hangs his head and closes his wings in fatigue as he rests on a Cathedral wall, looking down over a wide open, simplistically painted cityscape, where spires rise heavenward. The muted tones contrast with the angel's vivid attire, emphasizing his remoteness from the human world.

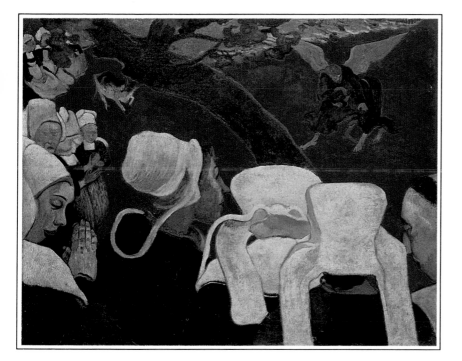

△ **Jacob Wrestling with the Angel – The Vision after the Sermon**
Paul Gauguin (1848-1903)

Oil on canvas

PAINTED IN 1888, this is the pictorial embodiment of Synthetism, Gauguin's theory of using flat, bold colours to symbolize the forces of nature. The painting combines Breton peasant life with religious allegory. The red ground highlights the visionary and imagined nature of the scene set before the peasant women. Gauguin wrote to Vincent van Gogh in 1888 that: 'The landscape and the fight exist only in the imagination of the people at prayer after a sermon.'

This story has also been represented by Delacroix (1857-60). Jacob wrestled throughout the night with an unknown angel by the side of a ford. In the morning, the angel touched the hollow in Jacob's thigh and told him that he would bless him and that his name would no longer be Jacob but Israel. The wrestling match has been seen as a fight between Jacob and God, or Jacob and his conscience. The angel is thought to have been Uriel, who is also known as the Face or Fire of God.

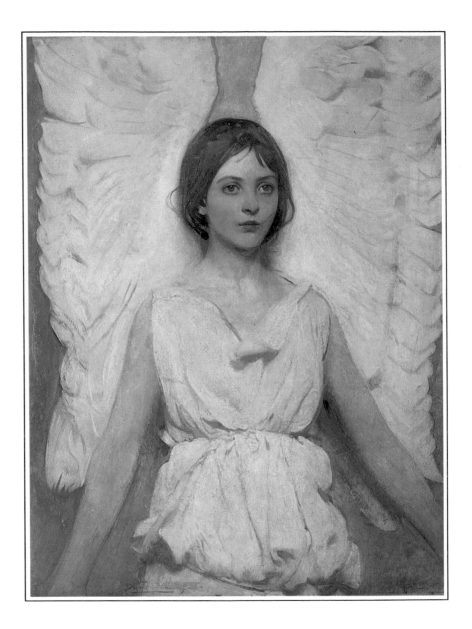

Detail

◁ **Angel**
Abbott Handerson Thayer
(1849-1921)

Oil on canvas

A BEAUTIFUL STUDY in 19th
century American realism,
Thayer's angel is depicted as a
young girl dressed in the colour of
ivory, with ivory-coloured wings
which frame the image like folds
of fabric. Her cheeks are slightly
rose-tinted, hinting at a sexual
awakening, yet she retains purity
and chastity still.

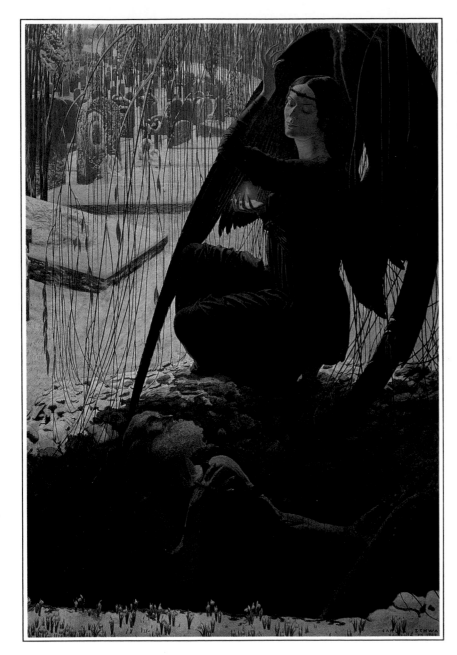

◁ **The Angel of Death**
Carlos Schwabe (1866-1926)

Oil on canvas

THIS IS A vainglorious image of the
Angel of Death enfolding man
under her wings, ready to escort
him to the kingdom of Heaven.
She is a classical image of beauty,
with her gorgeous jade dress and
long, fine fingers the epitome of
elegance and refinement. She
entices her subject out of his grave
to follow her. She is ever-young
and imbues a cool, green light
against the chill white snow
settling in the cemetery around
her. This is a realist Victorian
image in which Azrael, the Angel
of Death, is in control of man's
destiny. In mythology she sits on
the throne in the sixth heaven,
covered in eyes, and it is said that
when one closes, an angel dies.

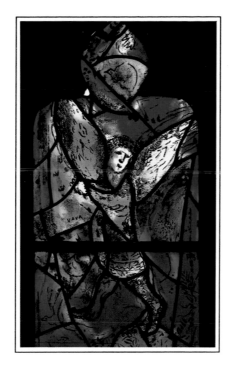

△ **An Angel**
Marc Chagall (1887-1985)

Stained glass

MANY OF CHAGALL'S paintings, drawings and stained glass windows contain subjects floating in the air – people, cows, candelabra – and sometimes angels. In this simple church window the angel's figure is simplified and, to a degree, abstracted. The angel lacks elegance, and appears more like a young boy than a celestial body. Chagall uses the colours of his painting palette in his choice of glass – blues, greens and pinks.

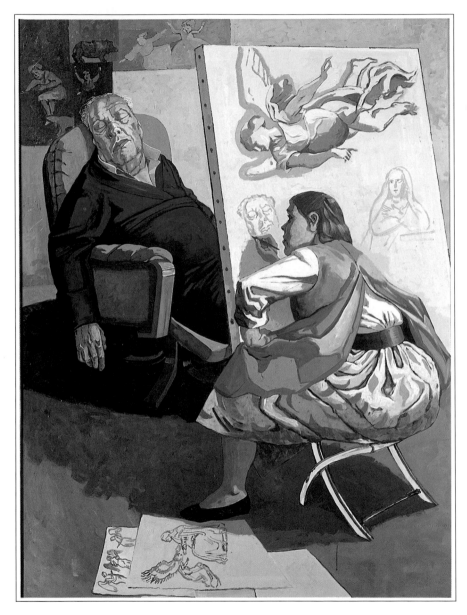

◁ **Joseph's Dream** 1990
Paula Rego (born 1935)

Acrylic on paper laid on canvas

JOSEPH, IN THE BOOK of Genesis, was said to have had two dreams which foretold of his superiority over his two brothers. Paula Rego painted her version of the dreams while resident artist at the National Gallery in London in 1990. It shows a version of Philippe de Champaigne's painting of Saint Joseph which hangs in the gallery. Rego's work is the final one in a sequence called *Time – Past and Present*. The little girl of the earlier works has now grown into an adult woman whose comely figure sits precariously on the stool as she draws angels of Joseph's dreams.

This is a modern painting and its religious imagery is used by Rego as a visual device to tell a secular story. It is a picture within a picture of another picture and Rego is the artist both inside and outside of the frame.

ACKNOWLEDGEMENTS

The Publisher would like to thank the following for their kind permission to reproduce the paintings in this book:

Bridgeman Art Library, London /Museo Diocesano de Solsona, Lerida/Index: 8; /**Scrovegni (Arena) Chapel, Padua:** 9; /**Museo di San Marco dell'Angelico, Florence:** 10; /**Bibliotheque Nationale, Paris:** 11; /**Hotel Dieu, Beaune:** 12-13; /**Louvre, Paris:** 14-15; /**Galleria degli Uffizi, Florence:** 16-17, 22-23, 30-32; /**Galleria dell'Accademia, Florence:** 18-19, 28-29; /**Accademia di San Luca, Rome/K & B News Foto, Florence:** 20; /**Staatliche Kunstsammlungen, Dresden:** 21; /**Prado, Madrid:** 24-25, 34-35, 46-47, 50-51; /**Museo Correr, Venice:** 26; /**Pushkin Museum, Moscow:** 27; /**National Gallery, London:** 33; /**Fitzwilliam Museum, University of Cambridge:** 36; /**Vatican Museums & Galleries, Rome:** 37; /**Private Collection:** 38; /**Unterlinden Museum, Colmar, France:** 39; /**Scuola Grande di San Rocco, Venice:** 40; /**The Trustees of the Weston Park Foundation:** 41; /**Oratorio dei Crociferi, Venice:** 42-43; /**Kunsthisorisches Museum, Vienna:** 44-45; /**Palazzo Doria Pamphili, Rome:** 48; /**Phillips, The International Fine Art Auctioneers:** 49; /**Hermitage, St Petersburg:** 52-53; /**City of Bristol Museum & Art Gallery:** 54-55; /**Rafael Valls Gallery, London:** 56; /**Courtauld Institute Galleries, University of London:** 57; /**Christie's, London:** 58, 70-71; /**Simon Carter Gallery, Woodbridge:** 59; /**Victoria & Albert Museum, London:** 60-61; /**Museum of Fine Arts, Budapest:** 62-63; /**Louvre, Paris/Giraudon:** 64-65; /**Tate Gallery, London:** 66-67; /**Church of St Peter & St Paul, Cattistock, Dorset:** 68; /**Musee des Beaux-Arts, Moulins/Giraudon:** 69; /**Palais de Tokyo, Paris:** 72; /**Musee Gustave Moreau, Paris:** 74; /**National Gallery of Scotland, Edinburgh:** 75; /**National Museum of American Art, Smithsonian Inst., Washington DC/Art Resource, New York:** Cover, Half-title, 76; /**All Saints, Tudeley, Kent:** 77 **Private Collection. Photo: Marlborough Fine Art (London) Ltd:** 78